8/97

THE APERTURE HISTORY OF PHOTOGRAPHY SERIES

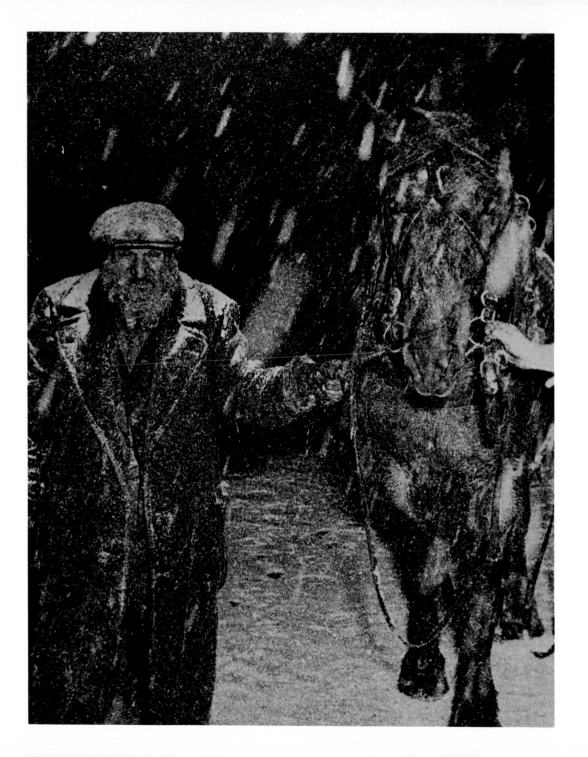

Weegee

APERTURE

Weegee is the eighth book in the Aperture History of Photography Series. The photographs were selected and sequenced by Marvin Israel.

Aperture, Inc., publishes a periodical, portfolios and books to communicate with serious photographers and creative people everywhere. A complete catalogue will be mailed upon request. Address: Elm Street, Millerton, New York 12546.

Library of Congress Catalogue Card No. 77-80020

ISBN 0-89381-021-5

Manufactured in the United States of America.

All photographs courtesy Center for Creative Photography, University of Arizona, Tucson, Arizona, with exception of pages 37, 67, 79 courtesy Witkin Gallery, page 57 courtesy Marcuse Pfeifer Gallery, page 75 courtesy Nina Rosenwald, New York City and pages 90–91 courtesy The Museum of Modern Art.

Weegee photographs are, for the most part, as direct as a blow on the knees with a baseball bat. Nothing stands in the way of understanding them. They need no captions. Unlike many photographers, Weegee refused discipline, developed no theories, cared so little about technique for much of his life that his early, greatest photographs have been criticized as slipshod.

Art gave Weegee no trouble. He never even bothered to think about it, as he knew little about painting or sculpture, the history of art or of photography. He saw no symbols in his subjects. He used his camera not to celebrate the people he photographed, but to make a living, a narrow, spare living. What he wanted was the freedom to be Weegee: some fame, some money (but not much) and women were the triple peaks of his desires. He achieved all. He also earned a reputation as an artist, a reputation that he apparently cared the least about. After his death, he won the renown epitomized by the trademark many of his picture editors saw as a gag: *Credit photo by Weegee the Famous.*

When he was young, Weegee gave off an air of middle age, his dark eyes restless, slightly vague,

his hair too long, curled in an unbrushed mat, his Speed Graphic in hand, a half-burned cigar in mouth. Even in winter he looked as though he had melted down within his crumpled clothes. All his coat pockets had zippers holding in films, lenses, miniature tools. A big man, he had a small, guttural voice, nasal, soft, and hoarse as if nodes bloomed on his vocal cords.

By the time he reached his thirties, Weegee had become loosely fat, shapeless, his clothes hanging on him like washing on a line. Later, when in the money, he went to a bespoke tailor in London, where he insisted that his suits be made two inches larger all around. He hated material to touch him. Within hours the suits appeared as though they had been bought off a pushcart on New York's Orchard Street.

Usher Fellig, later known as Weegee, was born June 12, 1899, in the village of Zloczew, Austria. Ten years later, with his mother and three brothers, he arrived in New York City to join his father, who had come earlier to earn the money for their passage. At Ellis Island, which he called "the most beautiful place in the world," an im-

migration officer changed Usher to Arthur.

The greenhorn family settled on New York's Lower East Side, where they lived a grade higher than the rats in the tenements. Put into school with no English at his command, he learned with fair rapidity, mainly because he loved to go to school. By the time he landed in the eighth grade, he decided to leave for good. Whatever money he could earn the family needed: his father, unskilled at pushcart bargaining, had turned poor rabbi. From then on Arthur took to the streets for his livelihood. Among his jobs in the next few years were candy butcher at burlesque houses, street photographer sitting kids on a pony for tintypes, dishwasher at the Automat. At eighteen he left home. Although he dedicated his second book, *Weegee's People,* "To My Mother," when he came to write his autobiography, *Weegee by Weegee,* he barely mentioned his parents and spoke of his brothers only as companions in steerage. Once on his own, he never went to synagogue, but he always kept Rosh Hashanah and fasted on Yom Kippur.

When he was almost twenty-four, Arthur Fellig tired of his undirected route through poverty and settled for a job in the darkroom of Acme Newspictures (later UPI) at twenty dollars a week. Refusing Acme's offer to send him out as a photographer if he would agree to wear a white shirt and tie, Fellig was stuck in the darkroom except for a late-night emergency which shot him out to cover a fire. For the next twelve years he ventured out only to photograph at night, spending his off-hours playing the fiddle in accompaniment to silent films at a Third Avenue movie house. In time he became a fire buff: his pictures of a three-alarmer brought in three bucks extra; a five-alarmer, five; false alarms, nothing. Eventually he became a stunt man developer, once developing his pictures in the motorman's cab in the subway on the way from the Battery to Midtown, once using a rented ambulance as darkroom to rush pictures of a world-champion fight at the Polo Grounds.

During this time he lived in a single, bleak bedroom in a rooming house, moving every month. For a while he camped out in Acme's darkroom, sleeping on a shelf. (On another shelf he kept his cache of kitchen supplies: Campbell soups, Heinz vegetarian baked beans, Uneeda biscuits.)

In 1935 he broke away from Acme's darkroom, and a fifty-dollar-a-week salary, to freelance. On an ordinary day he would leave his bedroom at five in the morning to drive around the city in his 1928 Ford. By 1942 he kept his equipment in the trunk of his Chevrolet. He monitored calls on a two-way police radio, the first one ever allowed a civilian. He also set up an informal office for himself at Police Headquarters on Spring Street, settling down in the Missing Persons Bureau. There he made his telephone calls, sent out his bills, met his friends.

Frequently, Fellig arrived on the scene of a disaster separately but simultaneously with the police. According to legend, the cops asked him if he had a Ouija board. From this came the onomatopoeic word Weegee. After he shot his

stuff, he wandered over to the *New York Post,* where he had a key to its darkroom. There he printed up his catch of catastrophes, ready to make the rounds of newspaper editors. His price: $5 a print. In those days, he said, "Crime was my oyster." Obsessed with the people of the streets, Weegee whirred up like an oversized quail. One of his most tender photographs is of four children and a kitten sleeping on a fire escape (page 79).

In his first ten years as a free-lance photographer, Weegee took "some of the best killing pictures" of his career. In *Weegee by Weegee,* his blunt, mythologizing autobiography, he wrote: "Sometimes I even used Rembrandt side lighting, not letting too much blood show. And I made the stiff look real cozy, as if he were taking a short nap." If the editors protested that the stiff didn't amount to much, Weegee had a handy protest: "What do you mean, it's no good. Look, he's a regular union gangster, a junior executive type. He eats at Chock Full o' Nuts. He's got on the pin-striped suit, a pearl gray hat, and his shoes are shined. He's a real up-and-coming Public Enemy." To that, an editor would say, according to Weegee: "We've got a standing rule that they have got to commit ten murders, and be high school graduates before they make the paper."

A man of the cities, Weegee remained throughout his life a provincial, an outsider by choice, a spectator, a sightseer. He cured himself of normalcy and made a masterly eccentric of the naked-city photographer. A night slob, he had, in Rebecca West's phrase for St. Augustine, "no addiction to unsparing self-criticism." Devoid of family, shy, with no responsibilities for anyone except himself, afraid to make lasting contact with people except through the camera, he lived quite happily. When he died, he left a legacy of 5,000 negatives and some 15,000 prints.

Those pictures constitute, in Susan Sontag's phrase, "useful maps of the real." Without making statements, without the amorphous vaporizings of many distinguished photographers trying to pin down some kind of philosophy of photography, Weegee made pictures that are often commentaries on the disorder of the streets. He photographed not the fires, but the firemen; not the gunmen, but their corpses; not the collapsing buildings, but the dispossessed tenants; not the fascinated spectators at calamities, but the agonized, shocked mothers, knowing their children were burning like chickens in early-morning fires. He left no rural landscapes, he had no feeling for still-life. Only people nourished him.

Weegee photographed for the most part disaster, horror. (He guessed that in his time he had photographed 5,000 murders.) In fact, he empathized with the physically ugly. Faces and bodies we might not relish seeing in life looked ravishing in his black-and-white pictures. Faces with lines that might have been drawn with ice picks took on beauty: among them, the old vegetable peddler with his horse in the snow (frontispiece); the bagelman; the flower seller, a bunch of roses covering one pebbled eye; the crying, shawled woman.

With these pictures, leavened later with lovers kissing, drinkers getting smashed in bars, laugh-

ing children (but not too many), amused audiences pleasured at the sight of the fat women in the cast of *Sammy's Follies-on-the-Bowery,* Weegee gave his public an eye on barbaric vitality, on street violence. Unfeeling, the public watched bared feelings. Of all of his people scenes, none is more exotic than his extraordinary Coney Island Beach (pages 90–91), the upright bodies crushed together like BB shot. In his way, Weegee made New Yorkers see their city as exotic as any Tuareg village in the Atlas Mountains.

At ease in the streets, Weegee was uneasy with the rich, the worldly. He saw them as funny. Undoubtedly his most famous, cruel and perceptive photograph is "The Critic" (cover). Shot at the opening of the Metropolitan Opera in the forties, it shows two women wearing jeweled tiaras, white ermine coats, and diamonds: the blonde, Mrs. George Washington Kavanaugh, with eight or nine diamond bracelets, a long diamond necklace and at least four orchids; the brunette, Lady Peel, with long diamond necklace and dangling diamond earrings. Looking at them, a slouching woman, thin, miserable, middle-aged, her hair scraggling, her expression furious, unbelieving, her mouth widened in a hiss. Out of camera range Mrs. Kavanaugh's bodyguard watched those jewels. Like Shylock, Mrs. Kavanaugh might have said to Weegee, "If you prick us, do we not bleed?" For Weegee, only the poor bled.

Although taken for the daily newspaper *PM,* the paper never used the picture. The *Daily News* did, paying Weegee $5. In 1948 Edward Steichen, then Director of Photography at The Museum of Modern Art in New York City, chose "The Critic" for his show *50 Photographs by 50 Photographers*. In an article published by *Vogue,* August 15, 1948, Steichen explained that the fifty, which included D. O. Hill, Arnold Genthe, Man Ray, Alfred Stieglitz, Eadweard Muybridge, Eugene Atget, Lewis Hine, Berenice Abbott, Harry Callahan, Edward Weston and Ansel Adams, were either landmarks in the history of photography or were making new landmarks.

Oddly enough, Weegee did not care much for some of those landmarkers. He told a friend that he had enormous respect for Lewis Hine and his austere photographs of the poor, of children in factories. He liked the Diane Arbus and Gene Smith pictures; put up with those of Penn and Avedon; thought Paul Strand a dope, his landscapes and doorways boring. He hated the work of Lisette Model and Berenice Abbott.

In 1956 Weegee changed his careless living habits when he and Wilma Wilcox, a tall, gentle, rather rural woman, became partners, working and living together. An orderly, executive woman of enormous charm with a rakish humor and an Iowan Quaker background, she undertook to straighten out the mess of Weegee's stuff. During that process, he moved into her red-brick house, which he called the "lace curtain house," on Cherry Street. Later they moved to a West 47th Street brownstone. Owner of two master's degrees, one from the University of Pennsylvania and the other from Columbia's New York School of Social Work, Wilma Wilcox worked for the Salvation Army Family Service Bureau, rising to

head their City Wide Program for five years before she and a psychiatrist created the Metropolitan Center for Mental Health. Wilcox and Weegee respected each other, increasing the richness of their lives. Until Wilcox came into view Weegee had led, even with changing backdrops, a narrow, restricted life in contrast to her open-window view. Where he was secretive, she was candid.

In his sixty-nine years Weegee developed into a prodigious worker. From 1925 to 1936 he was in the darkroom of Acme Newspictures. From 1936 to 1945 he took pictures as a free-lance photographer for a number of newspapers, including the *Herald Tribune,* the *New York Times,* the *Daily News,* the *Post,* the *Sun,* the *World-Telegram* and the *Journal-American.* Some of the papers owned syndicates, and many Weegees went out to newspapers all over the country. In addition, he serviced photo syndicates—and such magazines as *Vogue, Life* and *Look.*

In 1945 Weegee published the first—and best—of five books: *Naked City.* Then came *Weegee's People* in 1946; *Naked Hollywood* in 1953; *Weegee by Weegee* in 1961; and *Weegee's Creative Photography* in 1964. During those years, he became involved in films, his best the 1948 *Weegee's New York.* Earlier Weegee had sold the title *Naked City* to Mark Hellinger for a movie but he had no connection with the production.

From 1948 to 1952 Weegee had a fling as a Hollywood actor, a specialist in bums, derelicts and a variety of such other characters as a street photographer and a prize-fight manager. For some of these films he acted as technical adviser. Of all his filmwork, according to Louis Stettner's *Weegee,* the 1958 movie *Dr. Strangelove* owes a certain debt to Weegee. After Stanley Kubrick, its producer-director, called Weegee to London as a special-effects consultant, "Peter Sellers claimed that his acting technique in the film was inspired by observing Weegee."

During these years Weegee's work appeared in shows at the Photo League in New York; at Photokina, Cologne, West Germany; at Ligoa Duncan Art Center in Paris; and in two Museum of Modern Art exhibitions, one in 1948, the other in 1974. In 1959 at the invitation of the Soviet Union he went there as a consultant on photography, lecturing and showing his pictures in Soviet schools. Nine years later, on December 26, 1968, Weegee died of a brain tumor.

Weegee backed into his career. In his most striking and significant prints, harsh on high-contrast paper, nothing was planned. He cared little for deliberate pattern, for texture, for the filigree of light. Instead, he wanted snapshots of unabashed emotions, either brutal or anguished, out in the open. Placing little value on his $5 prints of victims as part of the grand tradition started by Daguerre, Weegee aimed for an assault on his viewers. He achieved it. His photographs catch rawness, immediacy, agony before thought, boisterous joy and boiling laughter. Meant for the trash basket after publication, Weegee's greatest photographs have an unsettling beauty and the power of unique images which, once seen, are never erased.

Allene Talmey

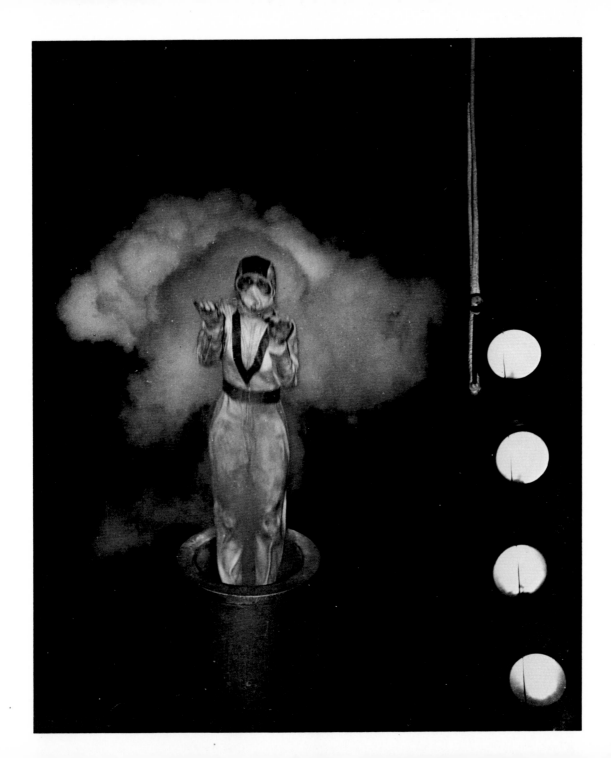

11

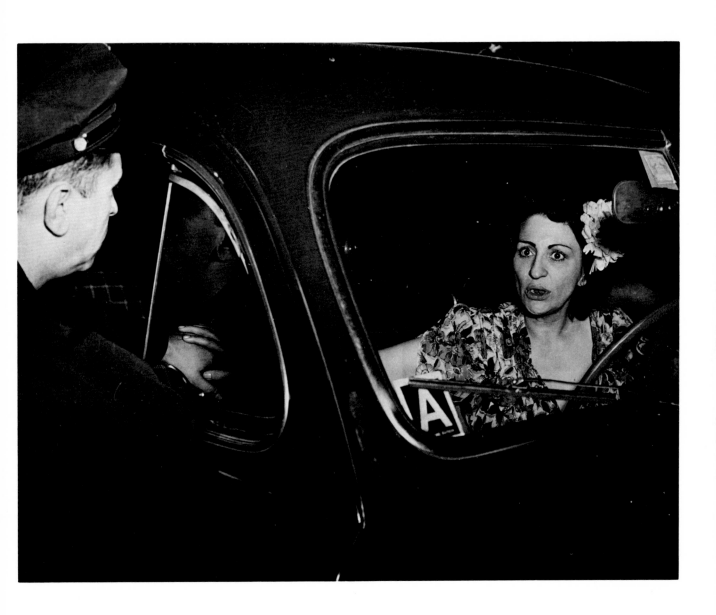

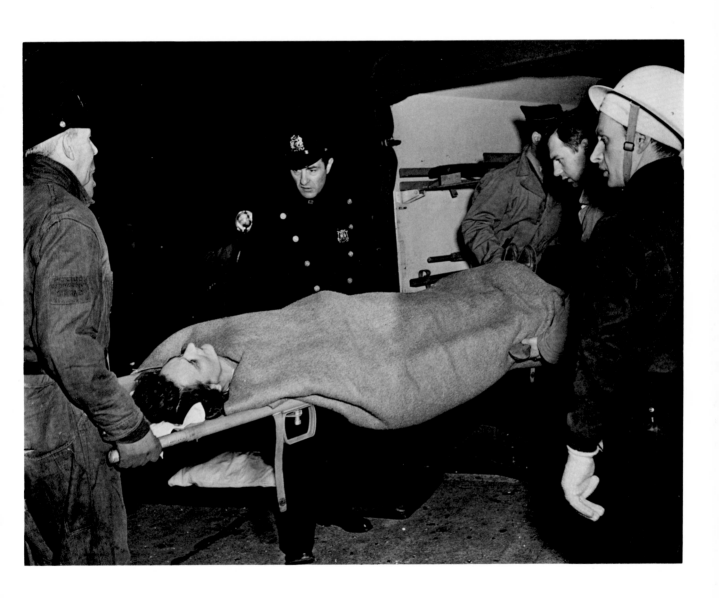

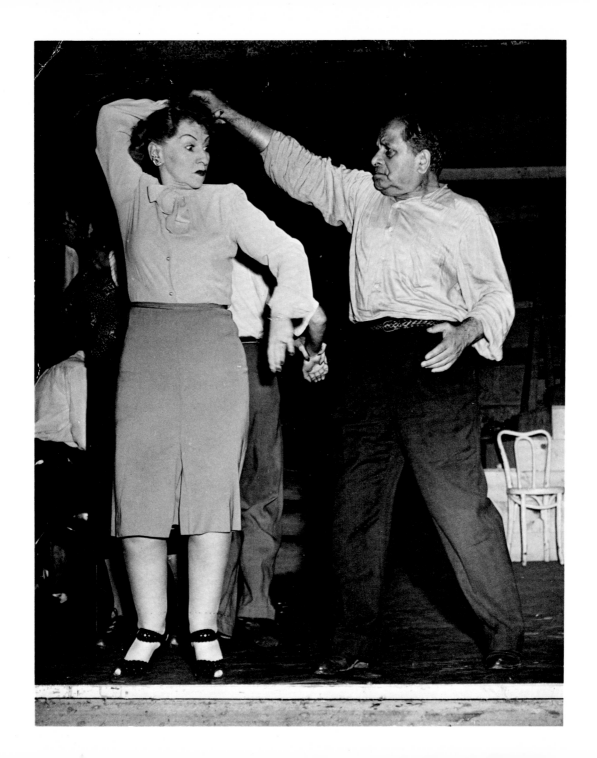

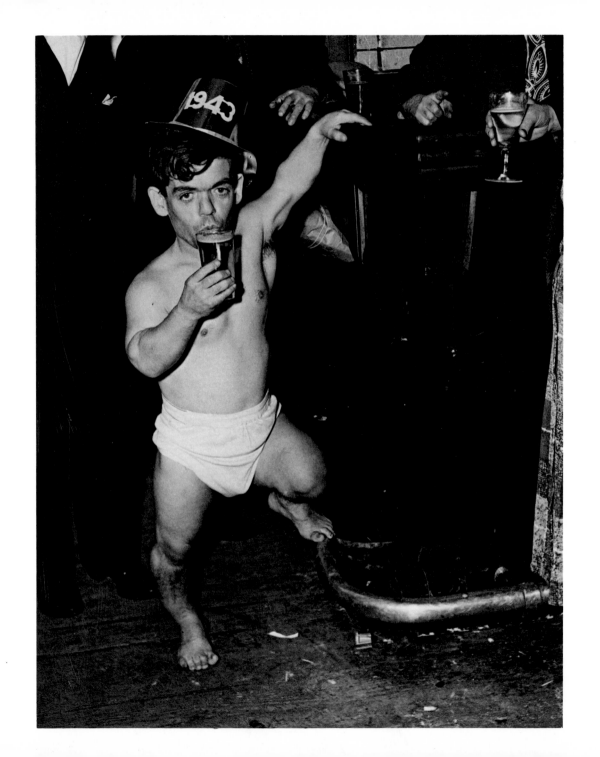

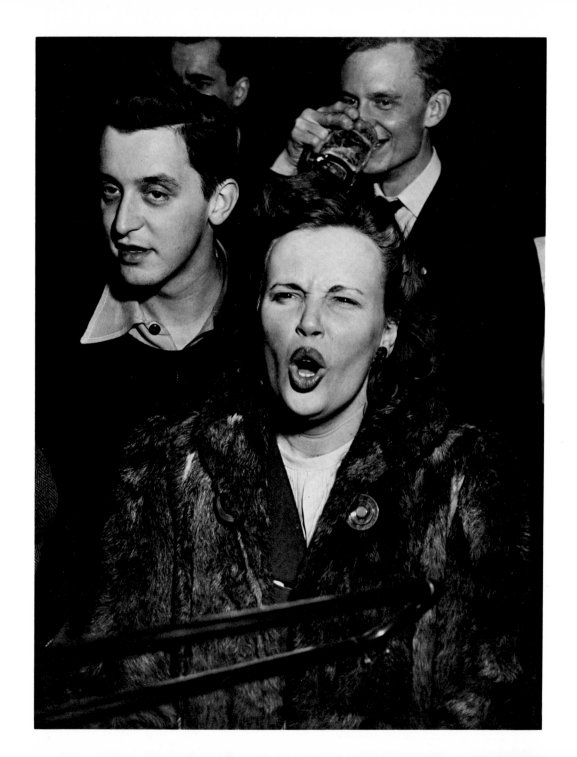

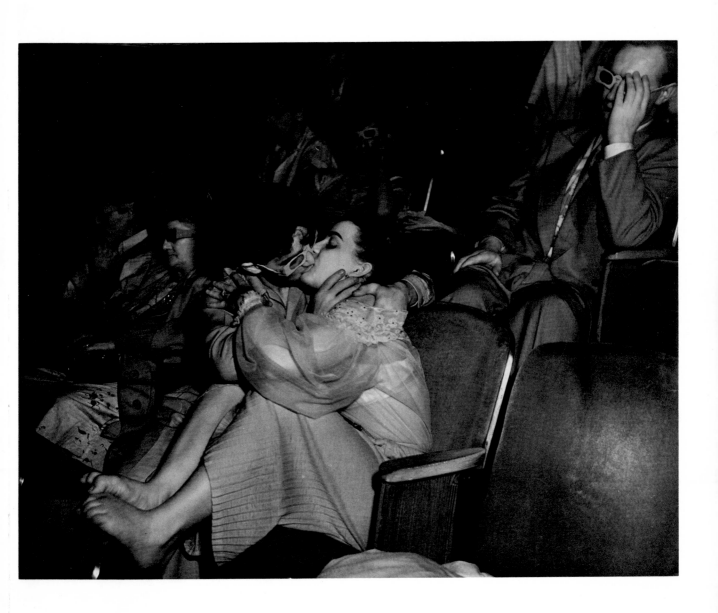

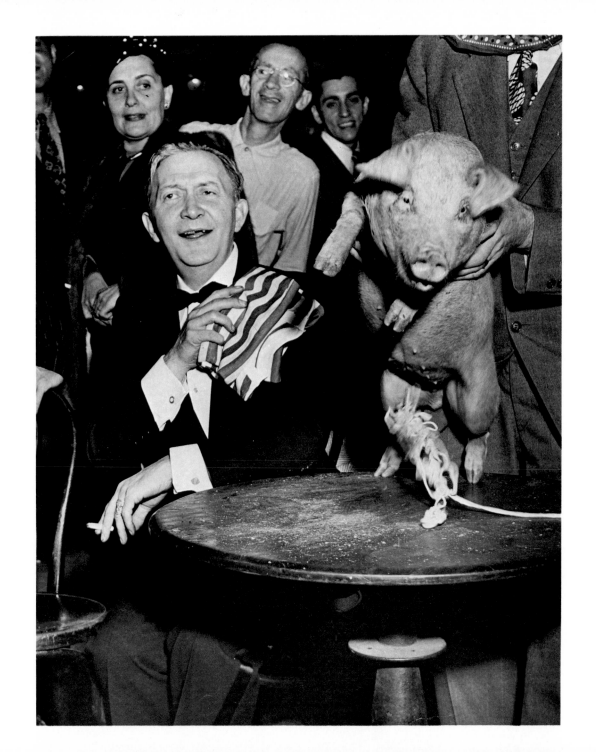

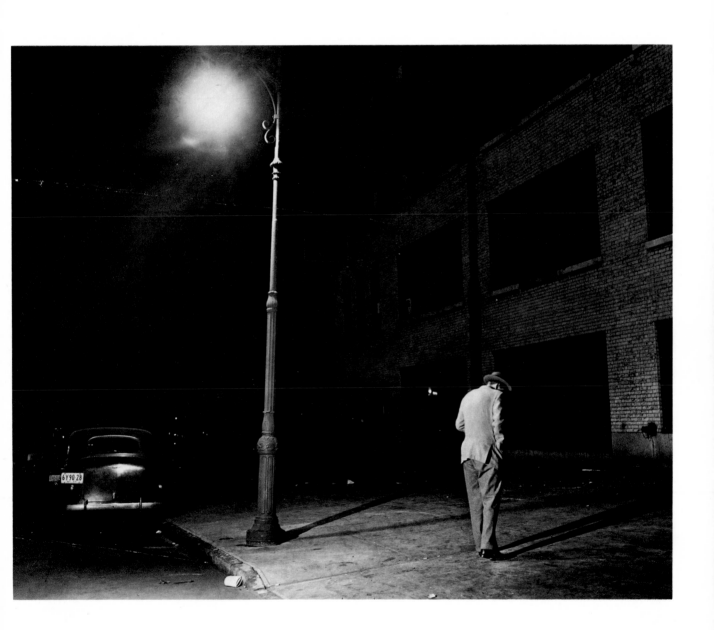

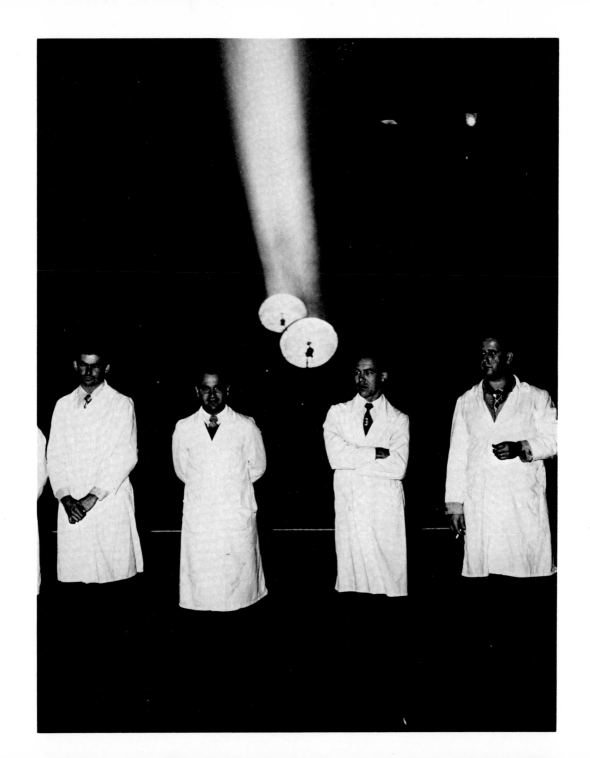

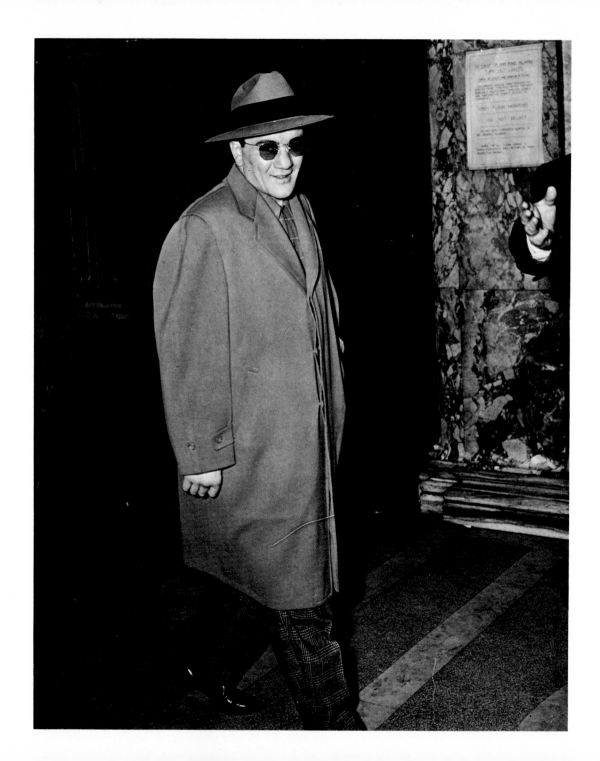

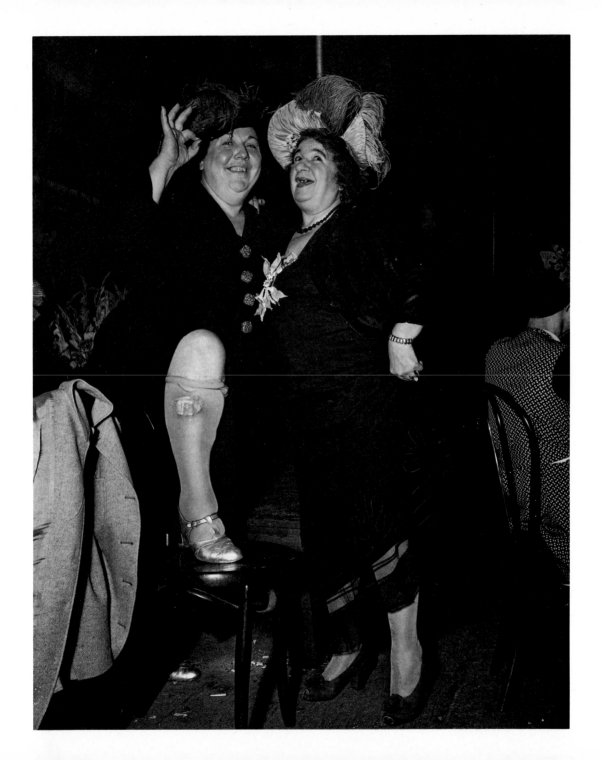

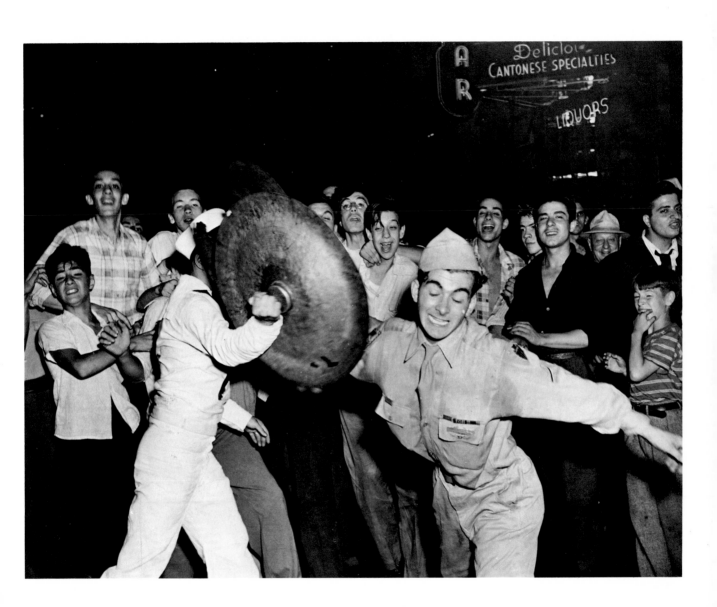

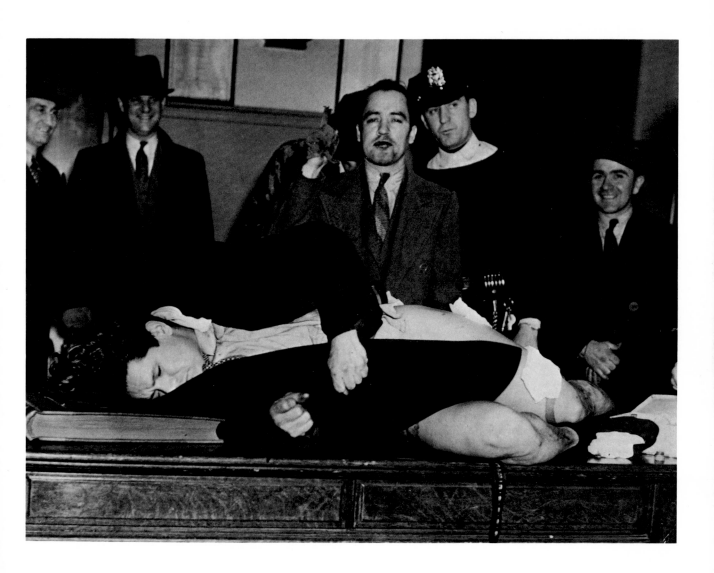

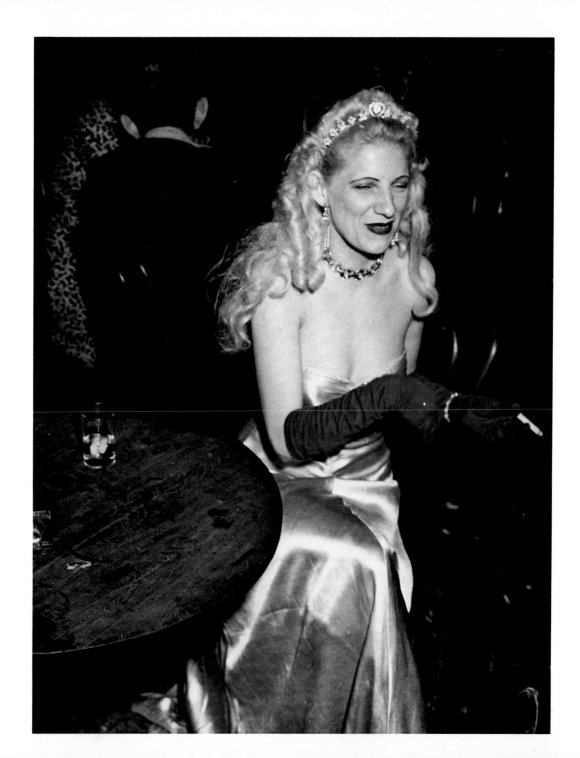

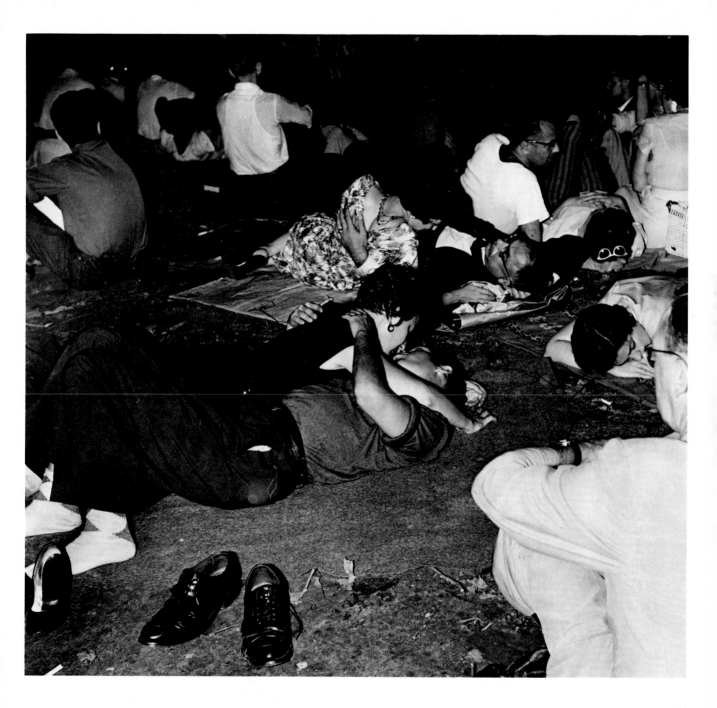

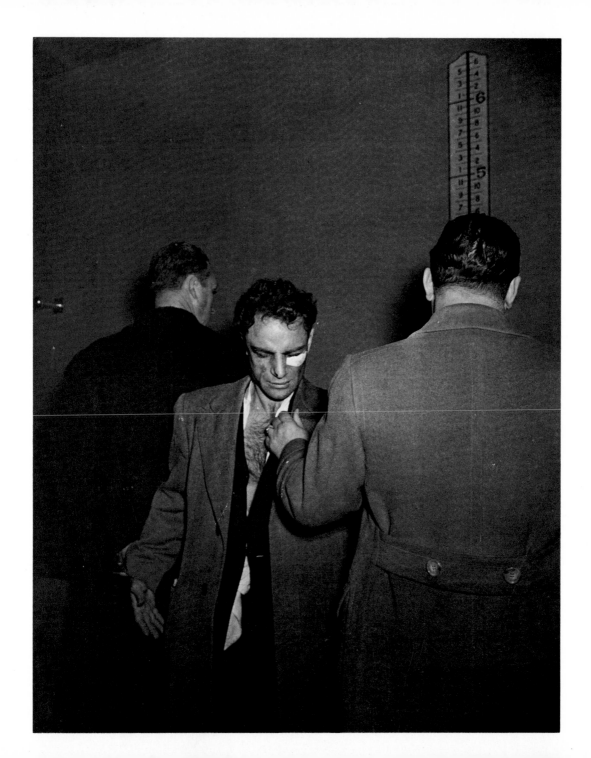

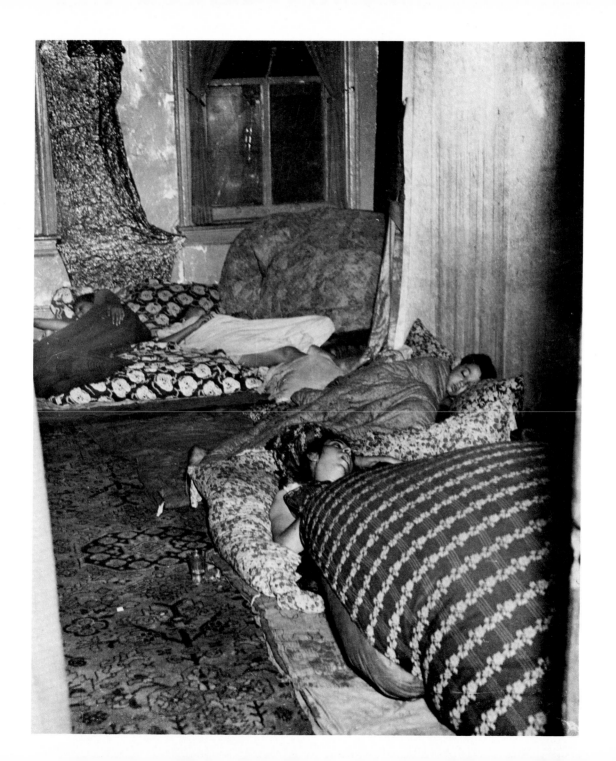

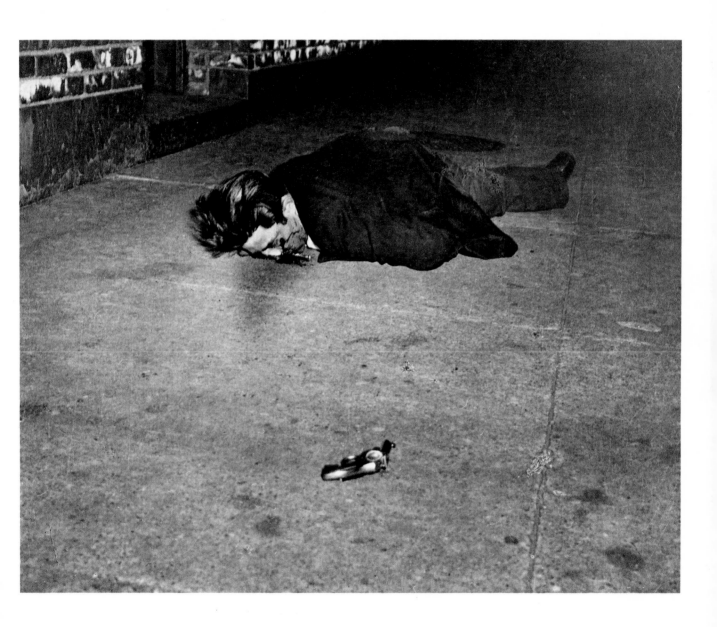

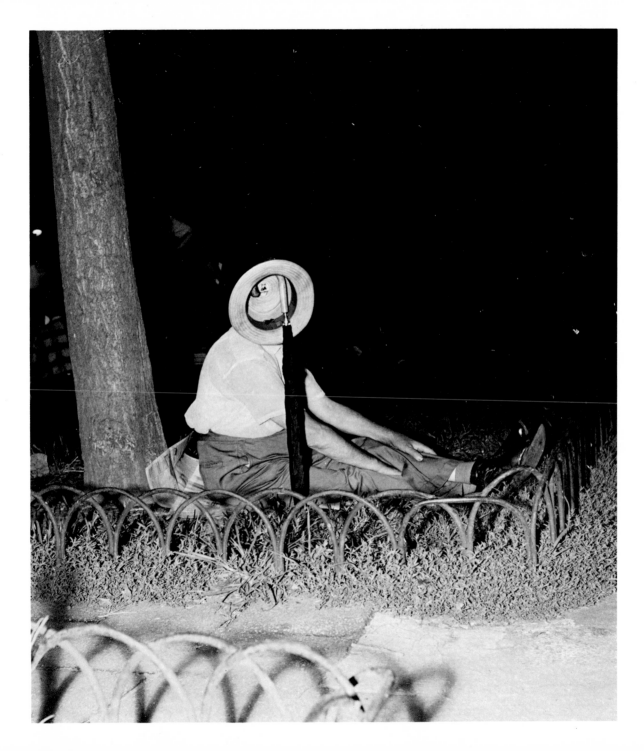

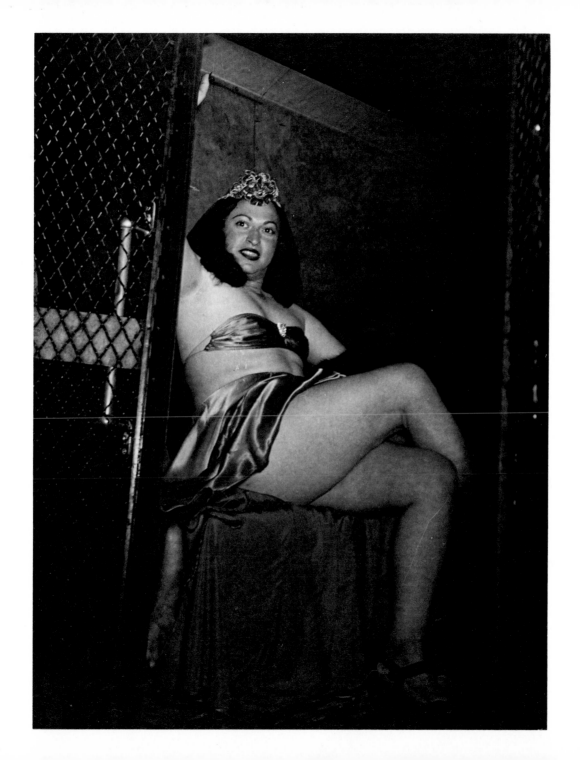

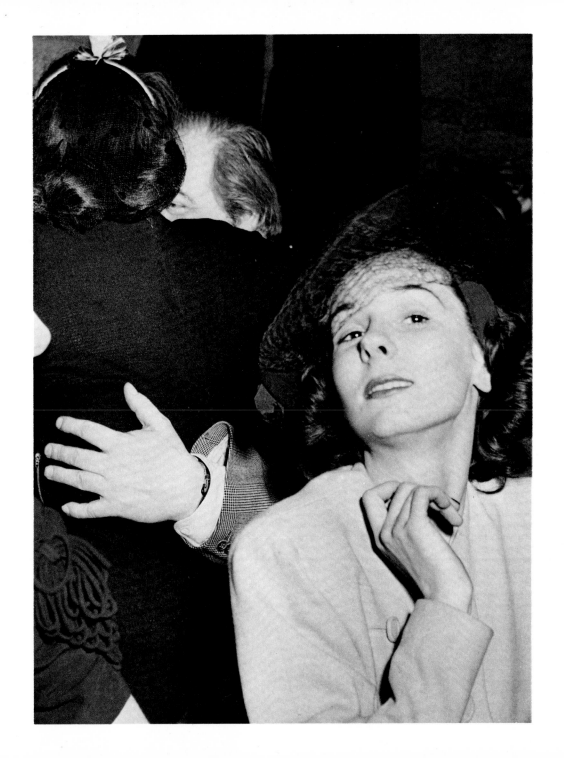

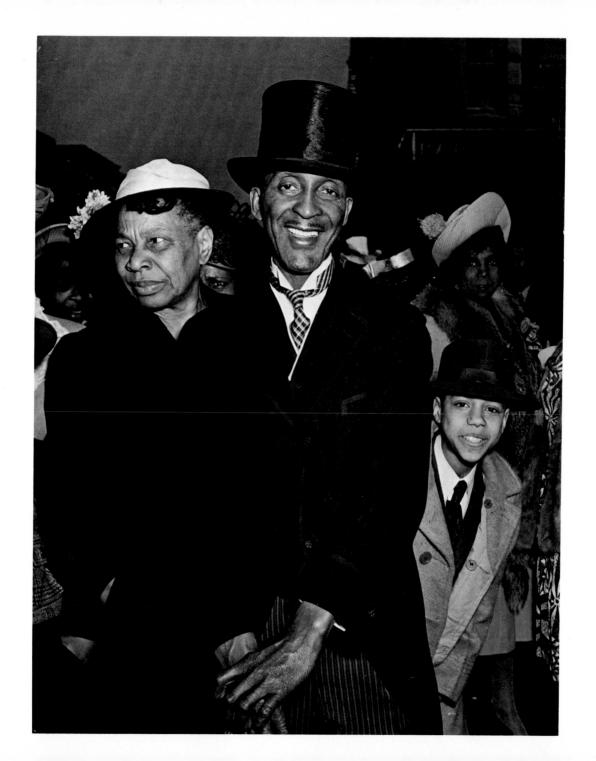

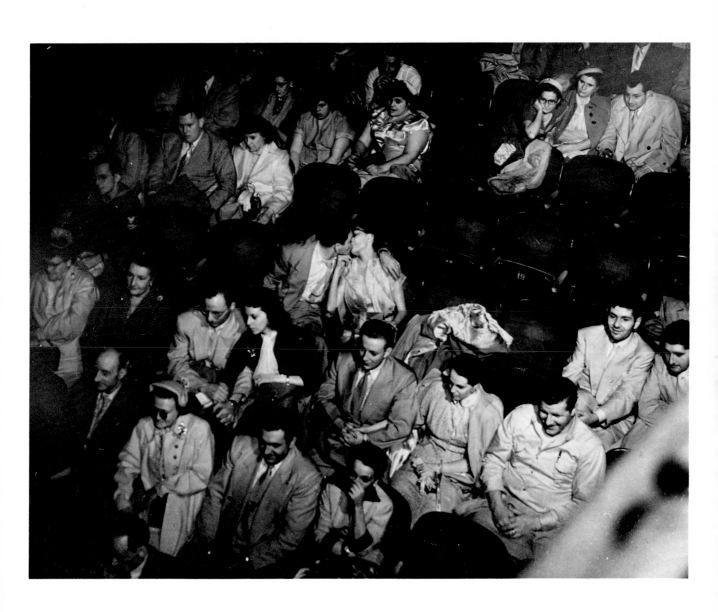

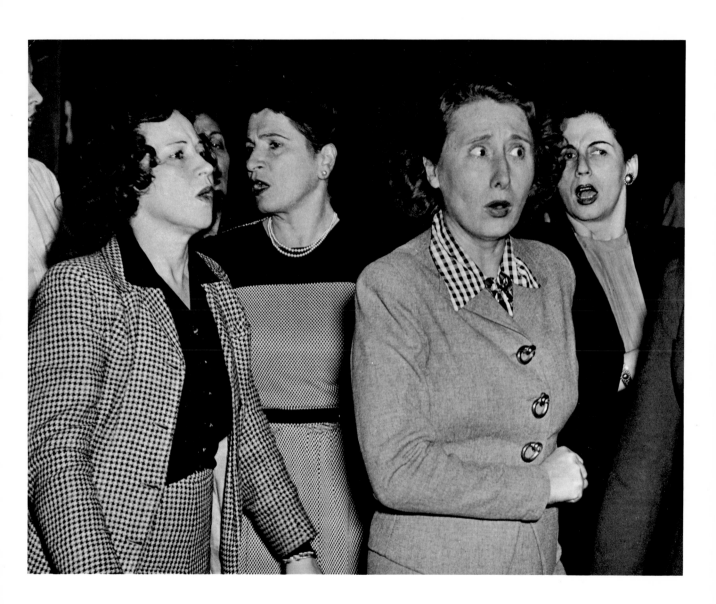

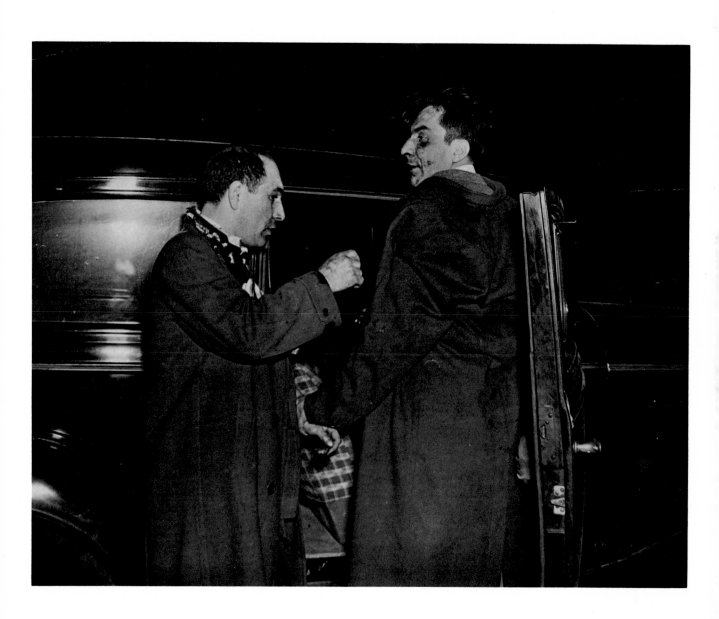

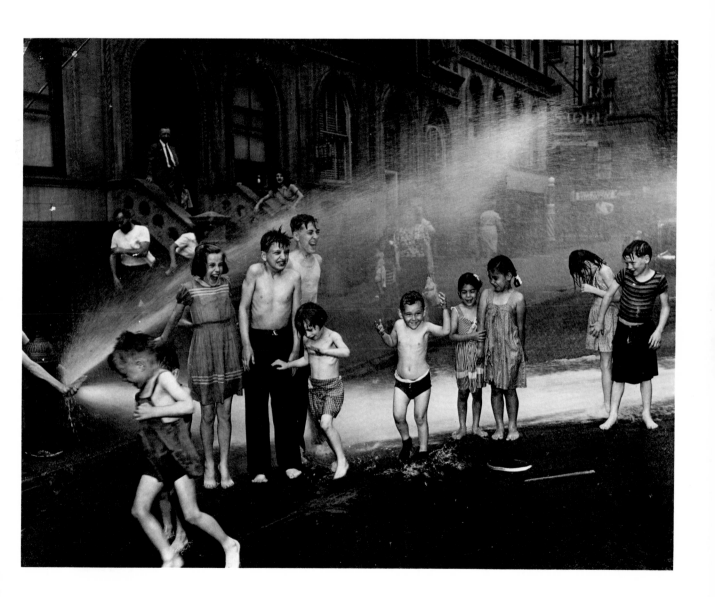

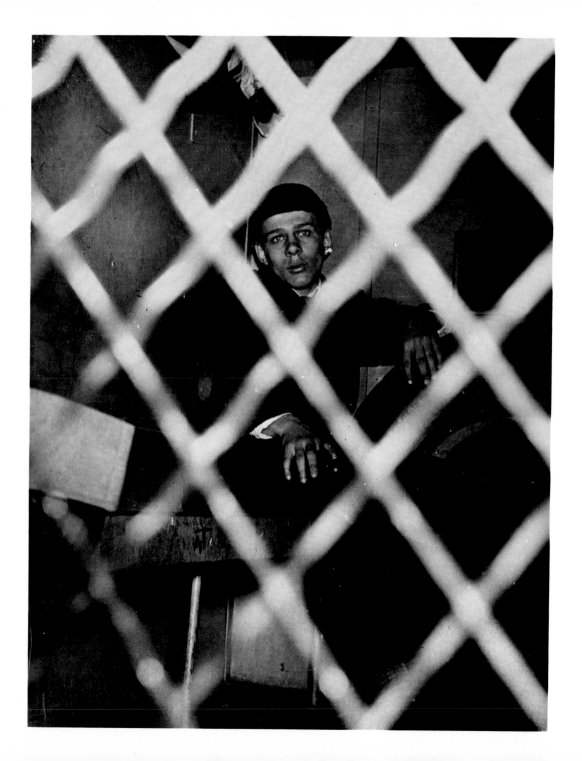

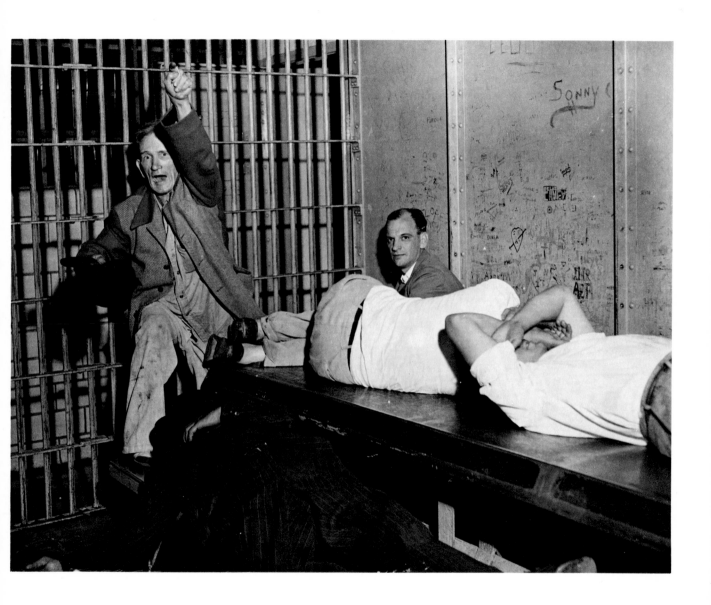

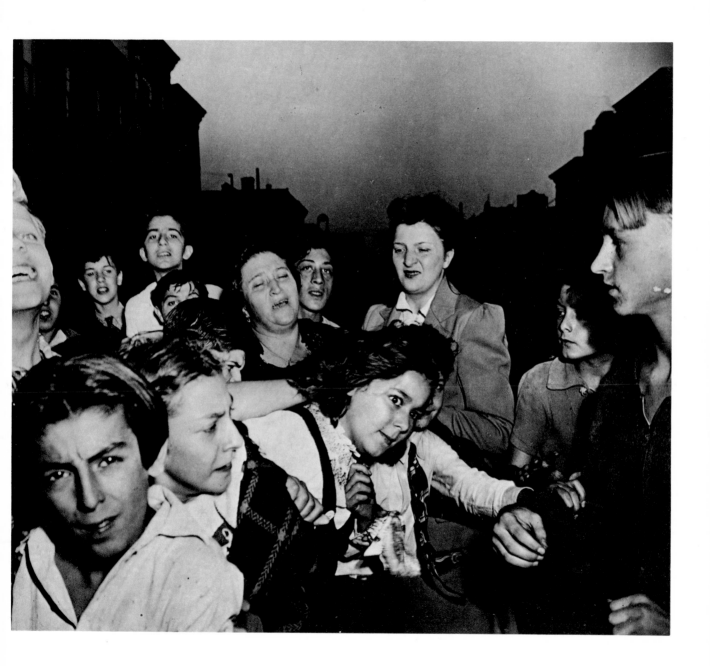

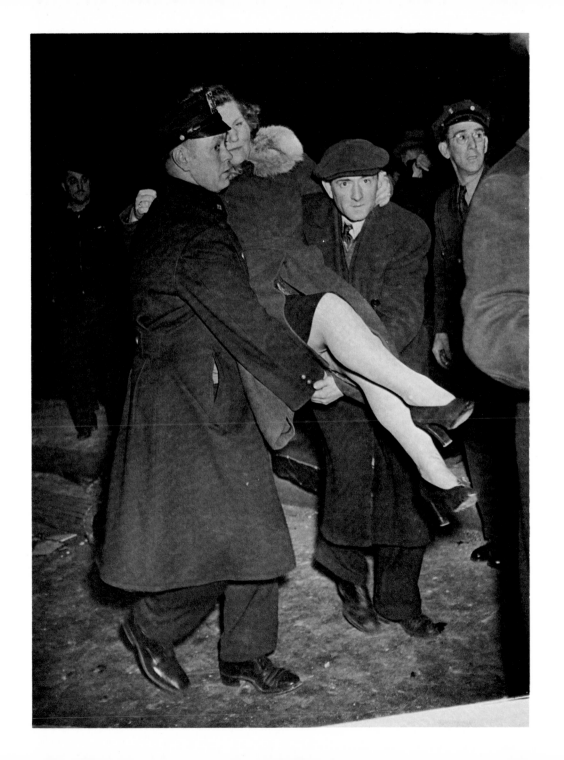

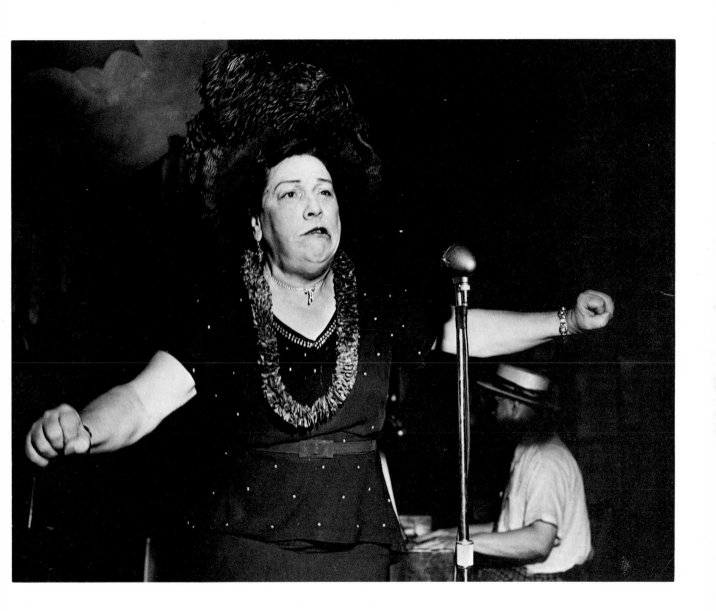

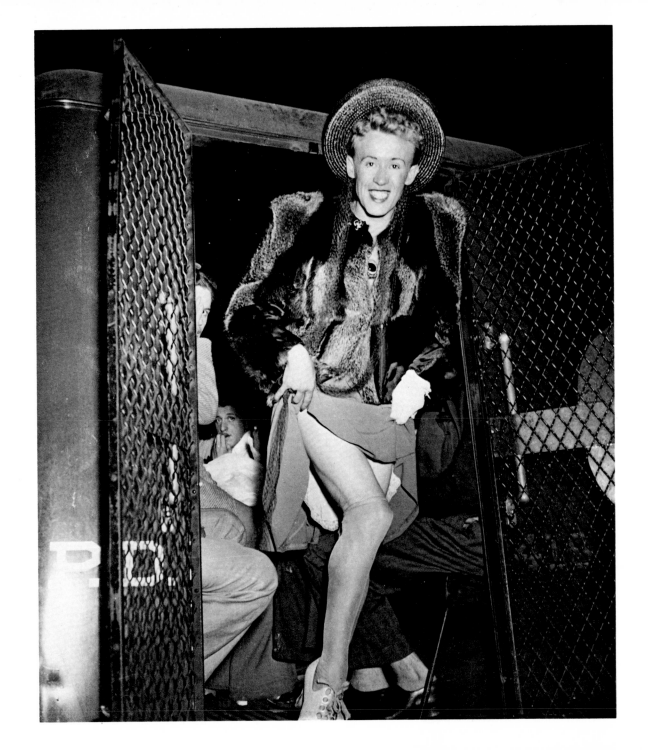

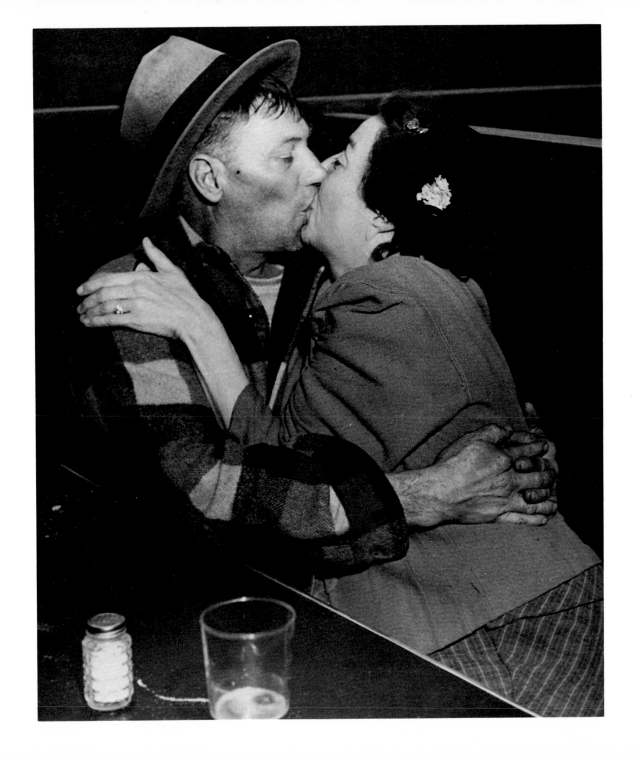

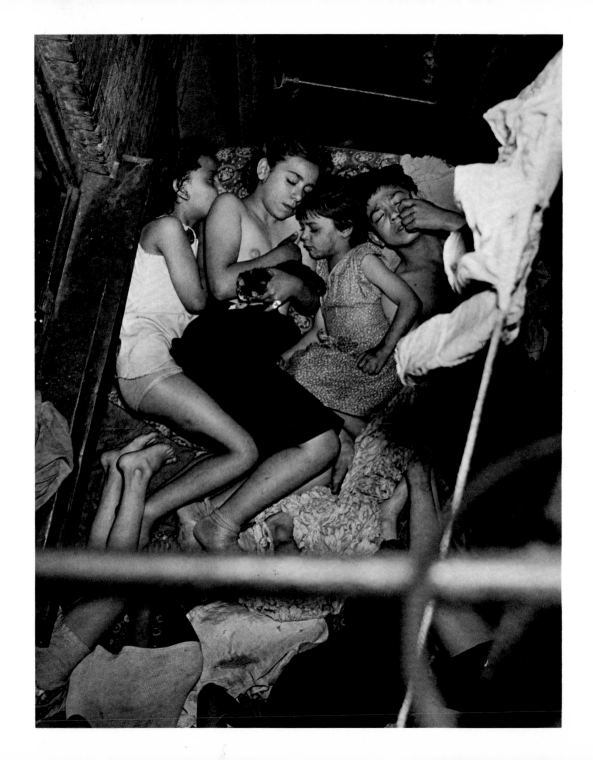

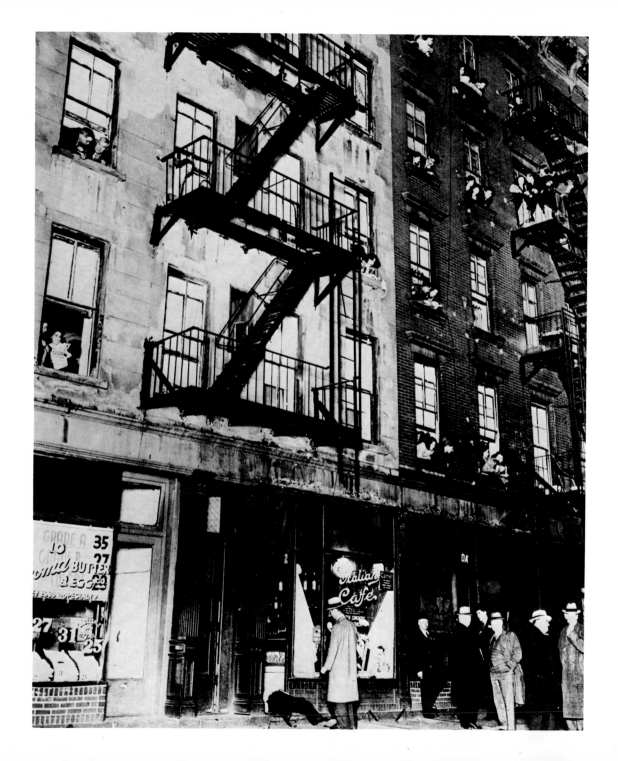

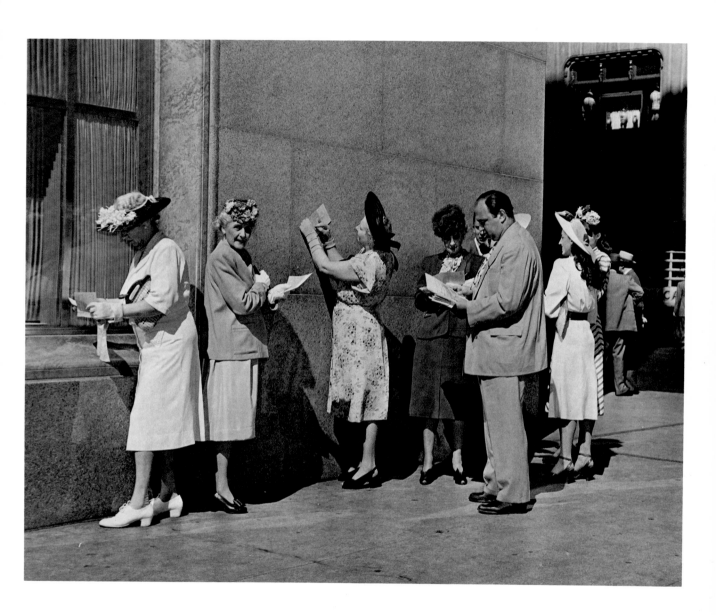

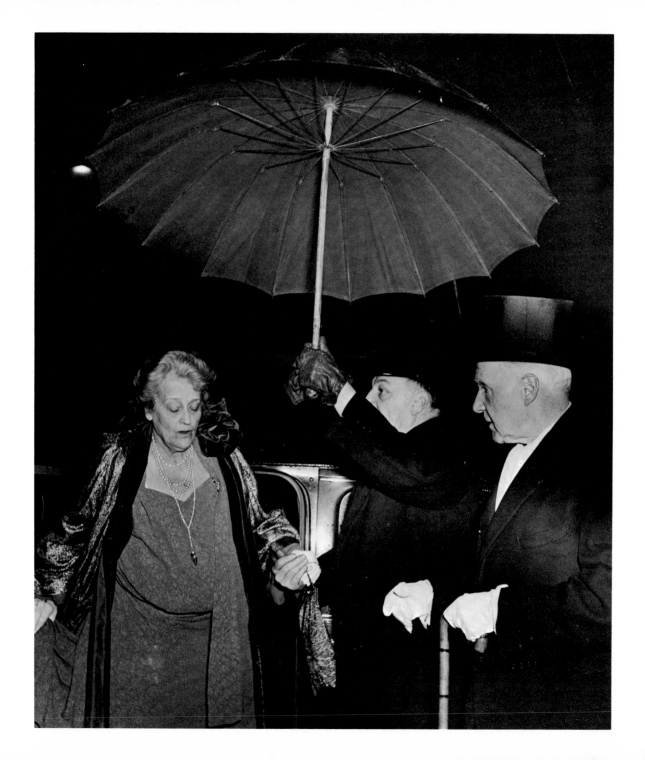

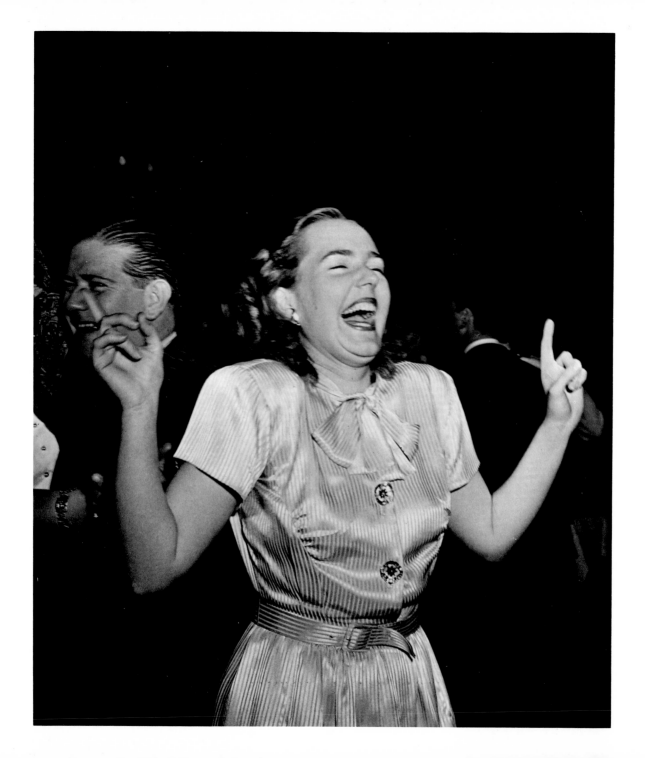

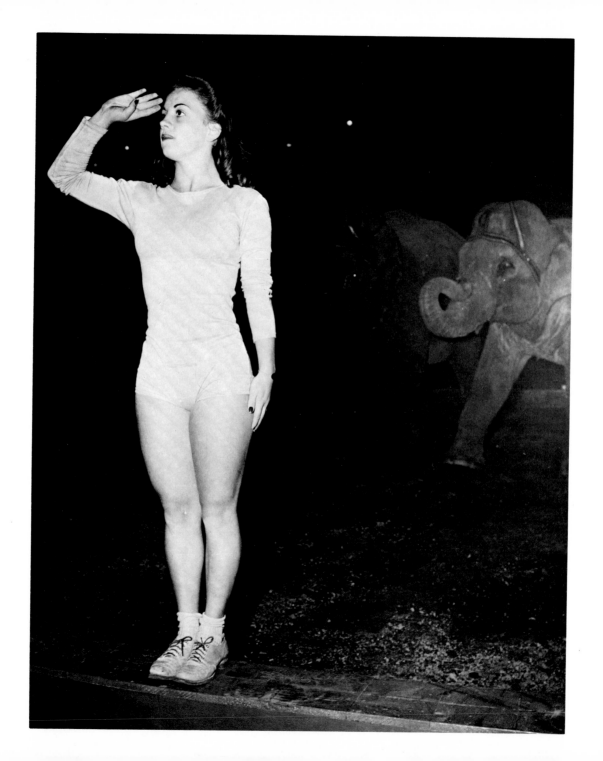

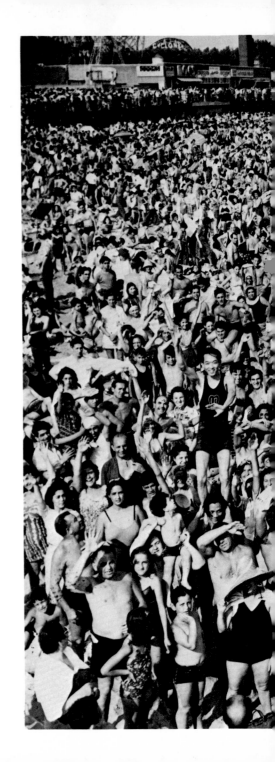

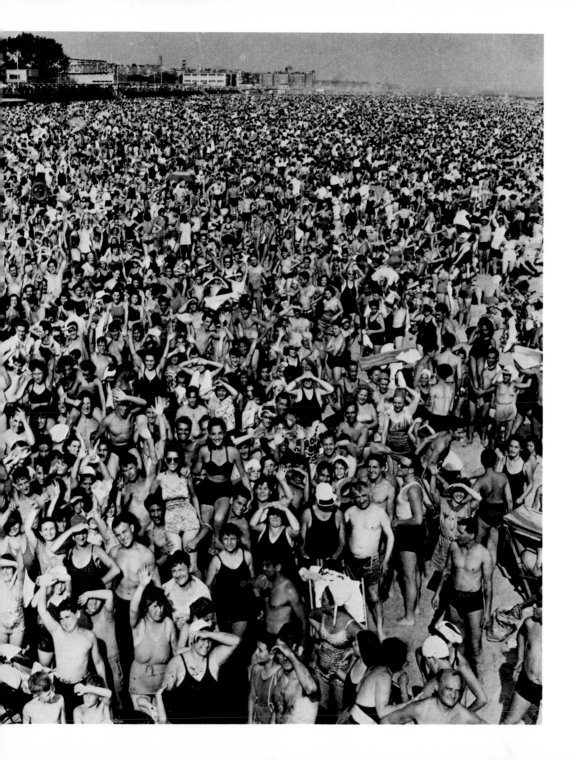

PHOTOGRAPHS

Front Cover: The Critic, c1943
Frontispiece: Vegetable Peddler, 1946

11. Cannon Shot, 1952
13. Accident Victim in Shock, n.d.
15. Concerned Policeman, c1943
17. Yiddish Theater Rehearsal, 1943
19. New Year's, Sammy's on the Bowery, 1943
21. Bar, 1948
23. Palace Theater, 1945
25. Party, 1947
27. Untitled
29. Movie Premiere, n.d.
31. Boxer Arrested, n.d.
33. Entertainers, Sammy's on the Bowery, c1944
35. Chinatown, n.d.
37. Untitled
39. Sammy's on the Bowery, 1940
41. Music Concert, Greenwich Village, n.d.
43. Booked for Killing a Policeman, 1939
45. Untitled
47. Murder in Hell's Kitchen, n.d.

49. Music Concert, Greenwich Village, n.d.
51. Transvestite in Police Van, 1945
53. Untitled
55. Easter Sunday, Harlem, 1940
57. Palace Theater, 1945
59. Metropolitan Opera House Rehearsal, n.d.
61. Argument Outside Madison Square Garden, n.d.
63. Summer, Lower East Side, 1937
65. Booked for Strangling Little Girl, 1944
67. Untitled
69. Their First Murder, 1936
71. Untitled
73. Untitled
75. Gay Deceiver, c1940
77. Untitled
79. Asleep on Fire Escape During Heat Spell, 1938
81. Balcony Seats at a Murder, n.d.
83. Registration, n.d.
85. Opening, Metropolitan Opera, n.d.
87. Untitled, 1942
89. Circus, n.d.
90–91. Coney Island Beach, 1940

BRIEF CHRONOLOGY

1899. Born June 12, Zloczew, Austria (Arthur H. Fellig).

1910. Emigrates with family to America; settles on New York's Lower East Side.

1913. Ends formal schooling to support family. Works as tintype photographer, as assistant to commercial photographer and at odd jobs.

1917. Leaves family. Holds variety of jobs including passport photographer.

c1924. Joins Acme Newspictures (United Press International Photos) as darkroom technician; fills in as news photographer.

1935. Leaves Acme to free-lance with Manhattan Police Headquarters as base.

1936–45. Free-lances for many New York newspapers and syndicates including *Herald Tribune*, *World-Telegram*, *Daily News*, *Post*, *Journal-American* and *Sun*.

1938. Receives official permission to install police radio in car; obtains scoop after scoop. Adopts name Weegee, phonetic rendering of Ouija board.

1940–44. Works for newspaper *PM*; is given complete freedom in choice of subject matter.

1945. Publishes first book, *Naked City*, an immediate success. Is retained by *Vogue*. Museum of Modern Art acquires several Weegee photographs.

1947. Leaves New York for Hollywood to consult on film version of second book, *Naked Hollywood*. Over next several years, plays bit parts in various movies.

1952. Returns to New York. Begins work on series of caricatures of public figures including John F. Kennedy, Nikita Khrushchev, Charles de Gaulle and entertainment personalities. Makes several short color films.

1958–68. Travels extensively throughout Europe and works on a wide variety of photo, film, lecture and book projects.

1968. Dies December 26, New York City.

SELECTED BIBLIOGRAPHY

BY WEEGEE

1945. *Naked City*. New York: Duell, Sloan & Pearce.

1946. *Weegee's People*. New York: Duell, Sloan & Pearce.

1953. *Naked Hollywood*. With Mel Harris. New York: Pellegrini & Cudahy.

1953. *Weegee's Secrets of Shooting with Photo Flash*. With Mel Harris. New York: Designers 3.

1961. *Weegee by Weegee*. New York: Ziff Davis.

1964. *Weegee's Creative Photography*. With Gerry Speck. London: Ward, Lock & Co.

ABOUT WEEGEE

1960. "Uncouth Genius," Louis Stettner. *British Photography* (December).

1968. "Weegee the Photographer Dies; Chronicled Life in Naked City," Harold Blumenfeld. *New York Times* (December 27).

1969. "Weegee, a Lens on Life 1899–1968," Harvey Fondiller, Norman Rothchild and David Vestal. *Popular Photography*, 64, 4 (April), pp. 93–100.

1971. "Speaking Out," Louis Stettner. *Camera 35* (July).

1976. "Naked Weegee," Gretchen Berg. *Photograph*, 1, 1 (Summer), pp. 1–4, 26–28. (Taped in 1965)

1976. "Night Light: Brassai and Weegee," Colin Westerbeck. *Artforum*, 15, 4 (December), pp. 34–35.

1977. "Weegee the Famous," Judith Goldman. *Quest/77*, 1, 4 (September/October), pp. 69–74.

1977. "Weegee the Famous," John Coplans. *Art in America*, 65, 5 (September/October), pp. 37–41.

1977. *Weegee*, Introduction, Louis Stettner. New York: Alfred Knopf.

FILMS

BY WEEGEE

1948. *Weegee's New York*. 16 mm, 20 minutes, color, sound.

c1950. *Cocktail Party*. 16 mm, 5 minutes, black-and-white, silent.

c1965. *The Idiot Box*. 16 mm, 5 minutes, black-and-white, sound.

ON WEEGEE

c1950. *Weegee in Hollywood*, Erven Jourden and Esther McCoy. 16 mm, 10 minutes, black-and-white, sound.

1957. *The Naked Eye*, Lou Stoumen. 16 mm, 71 minutes, black-and-white and color, sound.

MAJOR EXHIBITIONS

c1944. One-man show, Photo League, New York.

1948. Represented in "50 Photographs by 50 Photographers," organized by Edward Steichen, Museum of Modern Art, New York.

1959. Various exhibitions in Russia as part of a lecture tour.

1962. One-man show, Photokina, Cologne, West Germany.

1974. Represented in group show, "From the Picture Press," Museum of Modern Art, New York.